Similarity
A Photographic Contemplation

Michael Yacavone

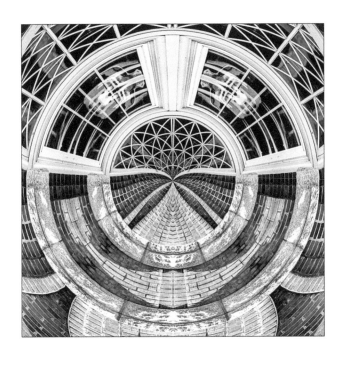
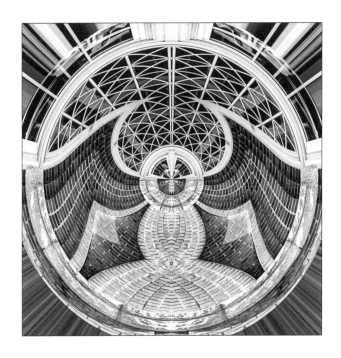

Copyright

Similarity: A Photographic Contemplation
Photographs and text by Michael Yacavone

www.SimilarityPhotos.com

Images featured in the book are available for sale as
high quality prints at www.MichaelYacavone.com

Thank you, Kathryn, for more than words can say.

.

ART / PHOTOGRAPHY / BODY, MIND & SPIRIT

Front cover: Journey to the Brick-Winged Owl Bat
Back cover: Here Now There Then

ISBN
978-1-7328012-0-2 (Hardback)
978-1-7328012-1-9 (EPUB)
978-1-7328012-2-6 (PDF)

First Edition, October, 2018 (v1.3)

Published by XeniumGroup, LLC, PO Box 828, Hanover, NH, 03755

Spiritual activities such as reflection and introspection pose inherent risks. The author and publisher advise readers to take full responsibility for their safety and know their limits. The author has decades of experience exploring the inner landscape. Do not take risks beyond your level of experience, aptitude, trainings, and fitness. Attempts to recreate any hazardous visions in this book are not recommended.

Similarity™
A Photographic Contemplation

Michael Yacavone

Hanover, New Hampshire, United States

Table of Contents

About *Similarity*

Similarity is an attempt to explore our world in ways beyond everyday awareness.

I've been fortunate to travel throughout the world. The experience has allowed me to understand the interconnectedness of life and to develop my compassion for our common humanity.

These journeys have also taught me that while our minds are quick to see differences, things are often more similar than they appear. Although our sensory apparatus is expert at making discriminations and distinctions, our higher order meaning-making systems are also at work actively seeking a through-line of commonality. These two systems are mutually dependent, the higher order system sorting through the stream of difference data looking for patterns, for unity.

Similarity targets that unity. In preparing this book, I evaluated over 55,000 photographs, most taken during travel in nine countries between 2015 and 2018.

I selected the most promising source images from experiments I made with digital manipulation software I assembled, my "aesthetic engine." The source images are manipulated by mathematically transforming their coordinate space, resulting in

pairs where one is an inverse transform of the other. (The full description of this software would be a book-length essay in itself, but basically it's a pixel-bending, polar matrix inversion apparatus.)

In the course of this work, I realized that the software is highly sensitive to minute, easily-overlooked aspects of a source image. For example, changes to the precise cropping along an edge, even in one- to four-pixel adjustments, or the geometric relationships of elements, or the proportions between, say, heavy and light areas, or textured areas and open space, all have a dramatic impact on the final images. The images are similar, and yet the images are different, and our mind reaches to understand how and why.

As I sorted through the results of a year's worth of these manipulations, living with and engaging with them, I noticed some things about how they made me think and feel. I found that if I spent fifteen minutes contemplating the twinned images before bed, I would fall asleep faster and sleep better, as though the contemplation had erased unnecessary patterns leftover from the day. I found it was a bit easier to get along with other people, because I was strengthening the muscle that helps me see situations from multiple perspectives. I found that I could help other people increase their capacity for leadership and make better decisions by finding commonalities everywhere they look and improving their ability to hold paradox in mind.

What I found the most rewarding was that contemplating the images both accelerated and amplified my ability to hold the witness-observer perspective. This was incredibly satisfying, and mind-expanding.

When I showed these images to close friends and we discussed their own experience with them, they reported a shift in themselves, too. That's what made me realize the potential of *Similarity*. There is a great and peaceful power that comes from looking at an image (or a life situation) and being able to notate the sequence of your mind's reaction. Becoming aware of and attuned to your own habits of reaction can create enormous flexibility in your responses to the world.

A fruitful way to approach the *Similarity* images is to give yourself over to them with immersive intent. Let them drift around inside your mind; linger on each pair to observe what emerges. Hold the book closer, then farther away; look at the edges, then concentrate on the center; look outward along the spokes; defocus your eyes; lose yourself; examine the textures; find a triangle; look carefully at a tiny element; search for concentric circles; trace the shapes with your fingers; look for animals or faces; observe the light areas, then the dark; discover subtle symmetries; notice the balance between elements. You might find that even apparently simple images have significant offerings.

When engaged with seriously, attentively, and mindfully, *Similarity* can encourage your mind to see how it sees.

Michael Yacavone
Hanover, NH, United States
October, 2018

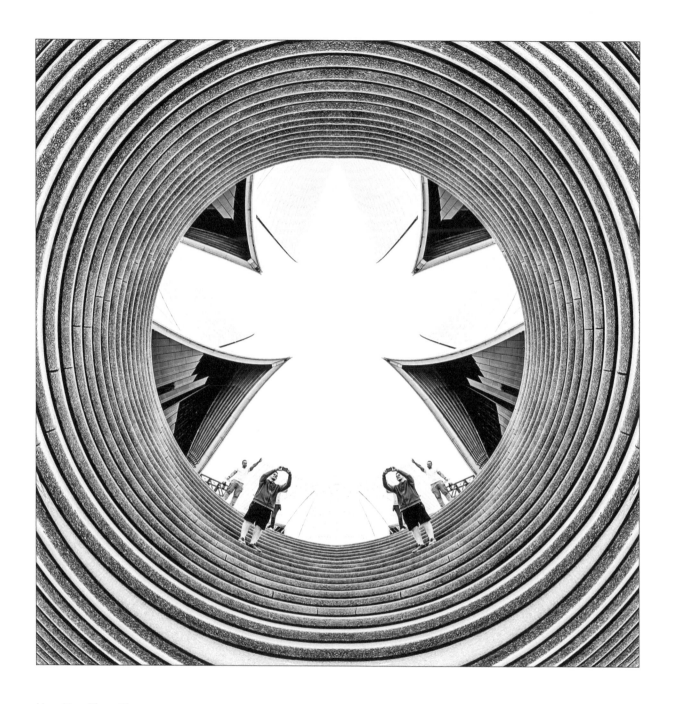

Here Now There Then

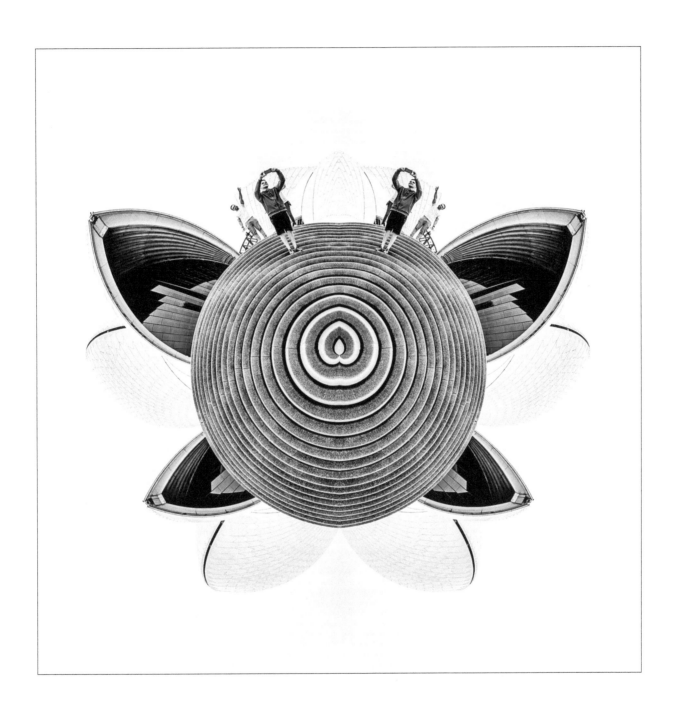

Sydney, Australia

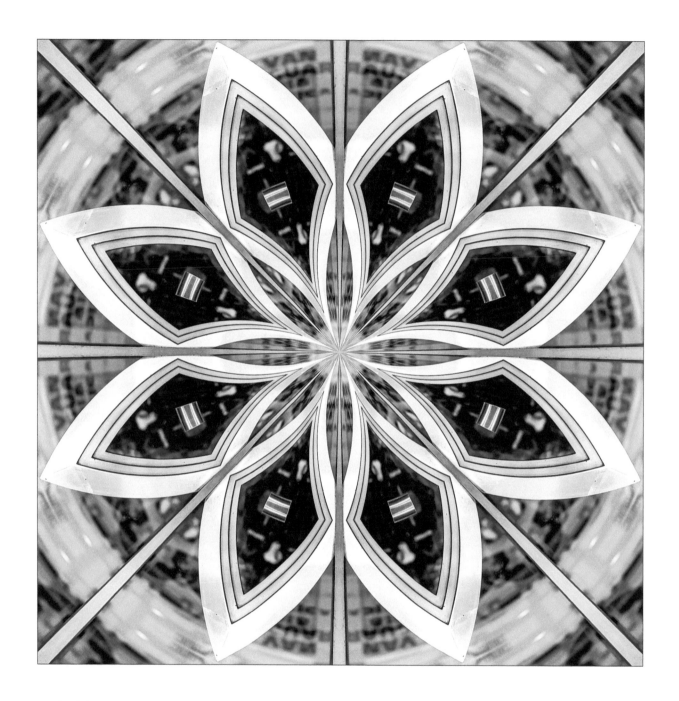

Petals of Illusion

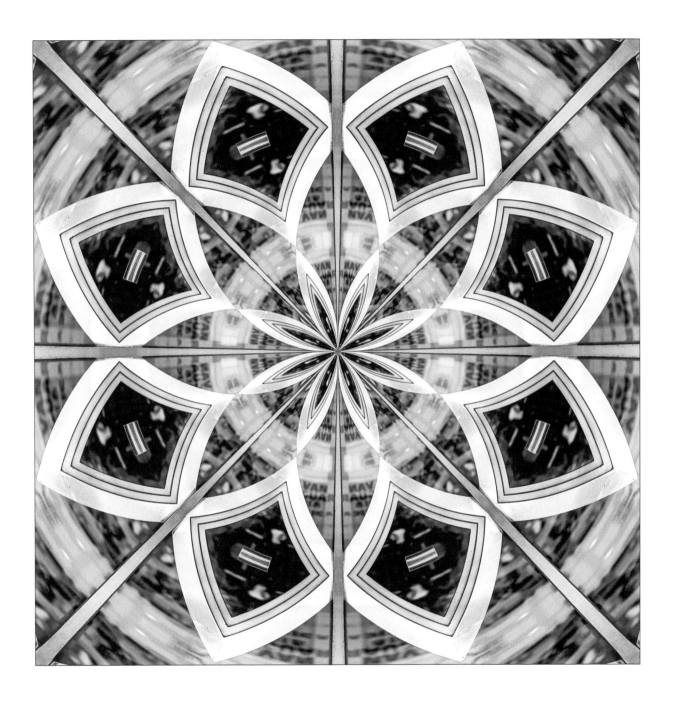

Mexico City, Mexico

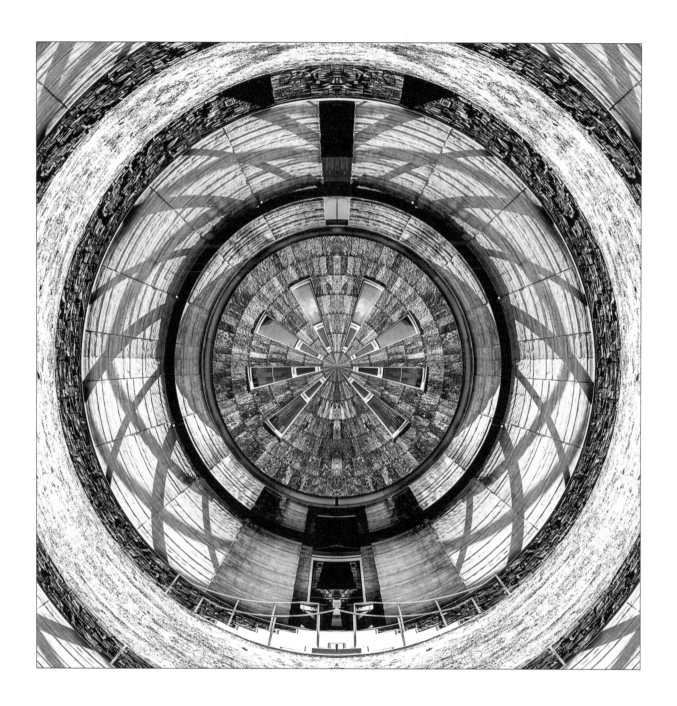

Conceptual Continuity

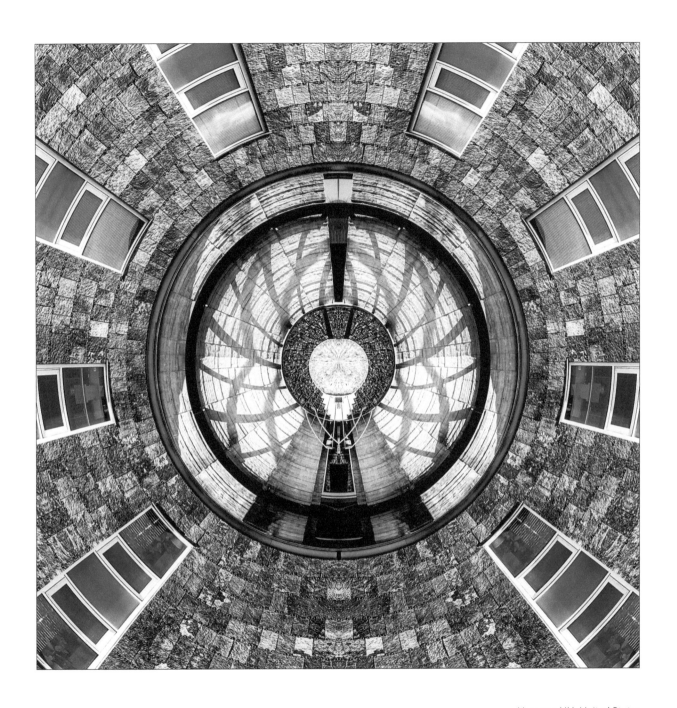

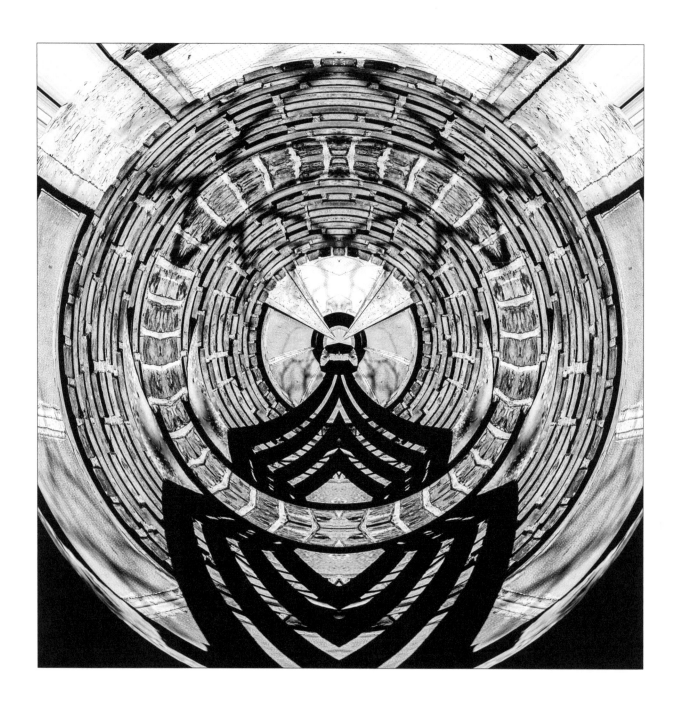

Samsara Samurai Swami

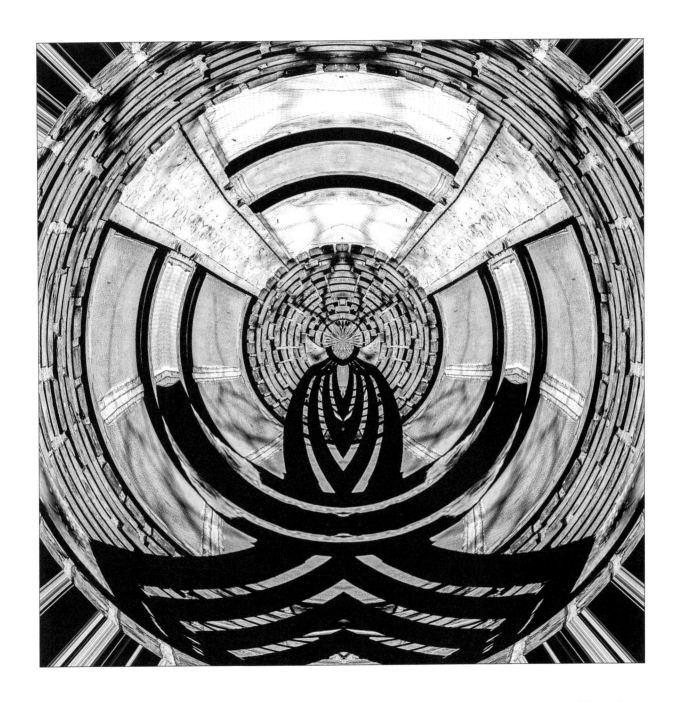

New York, NY, United States

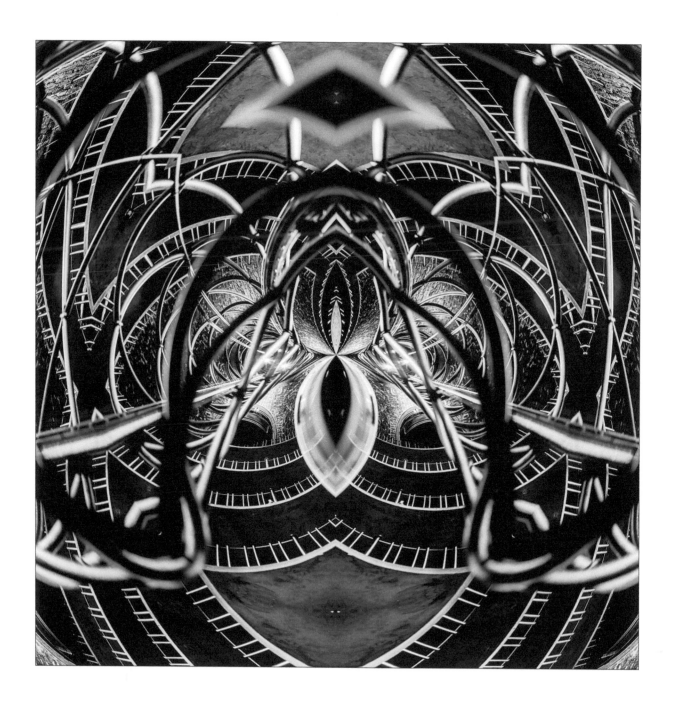

Metal Spiders Clowning

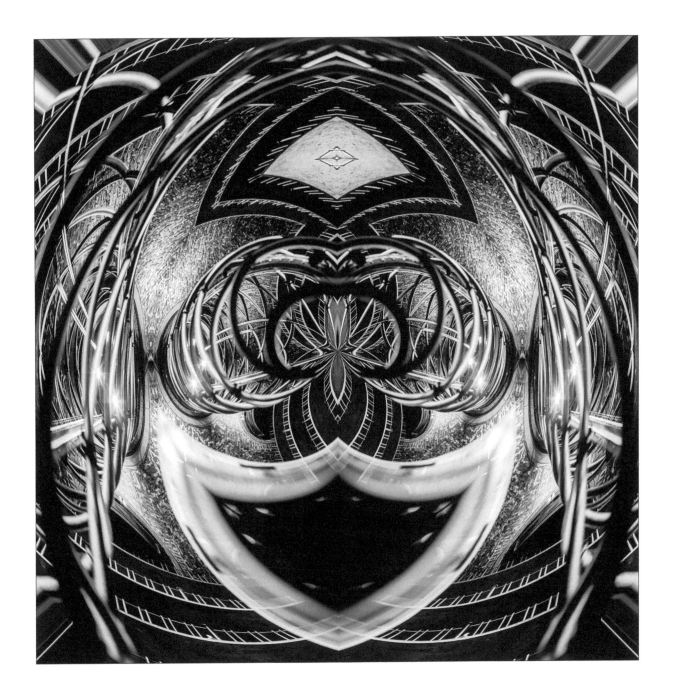

Prague, Czech Republic

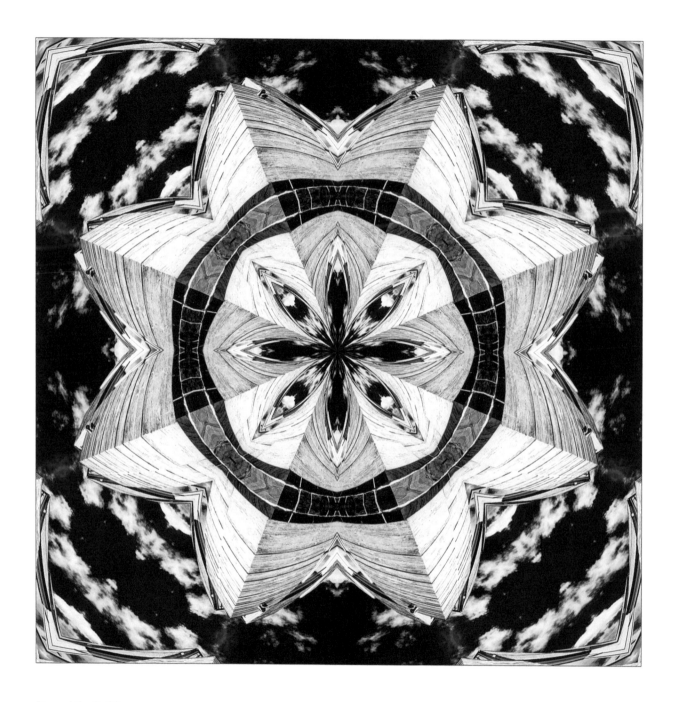

Beyond the Building

16

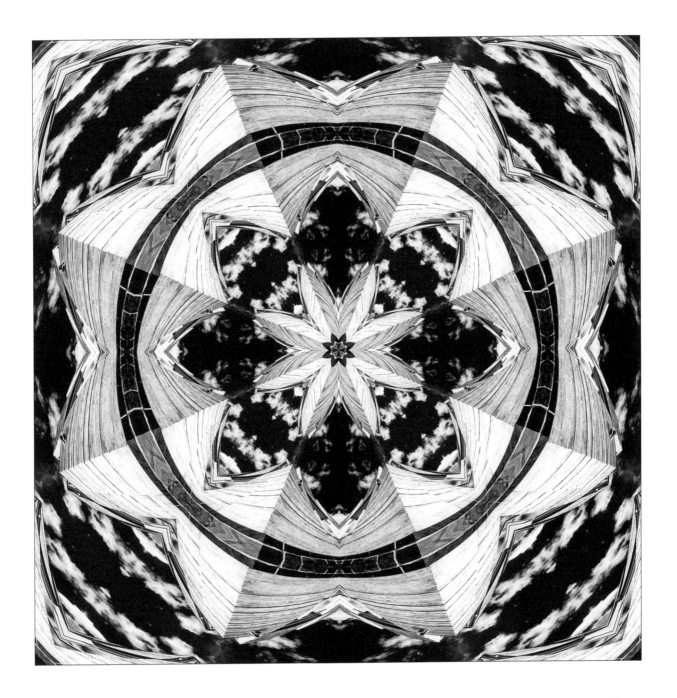

Hanover, NH, United States

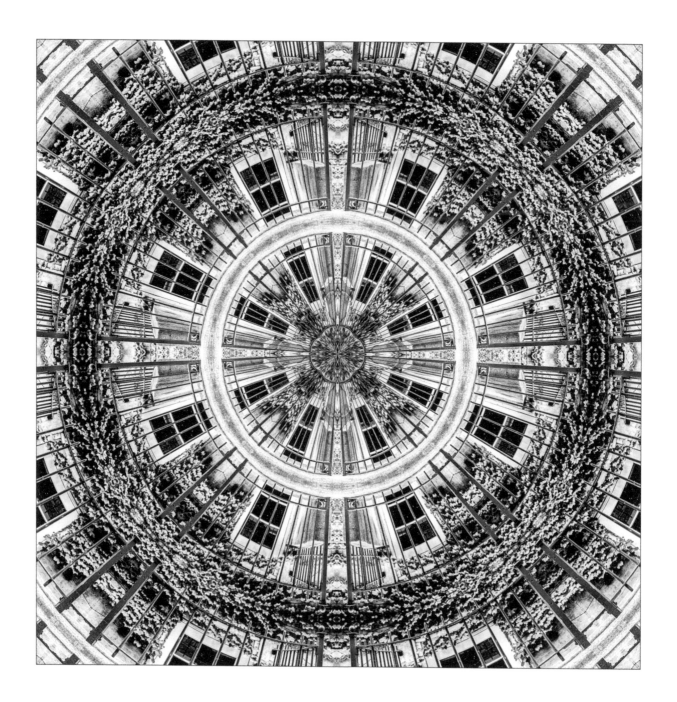

Looking Into the Window Well

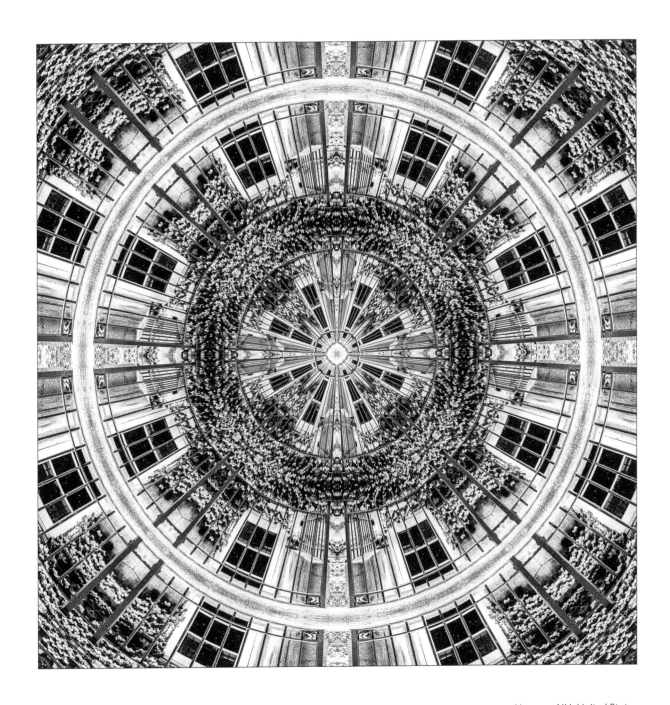

Hanover, NH, United States

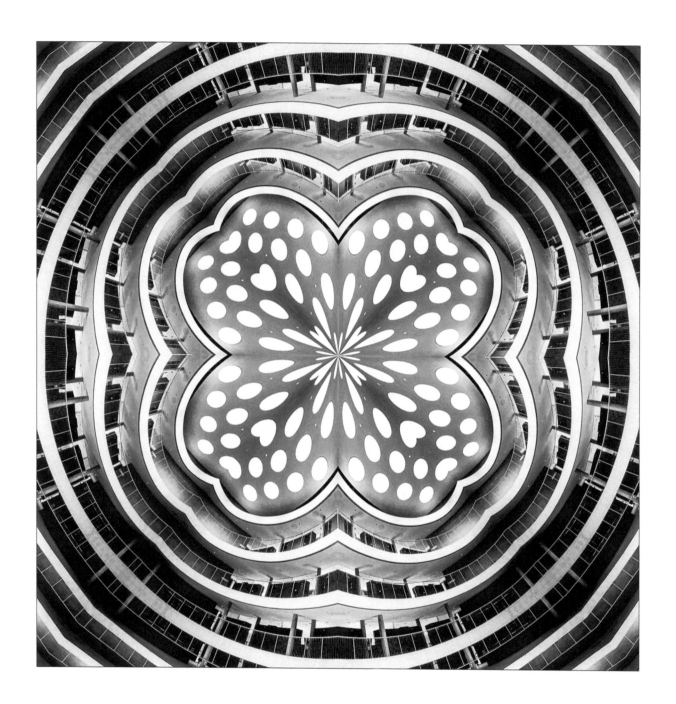

Each Contained Within the Other

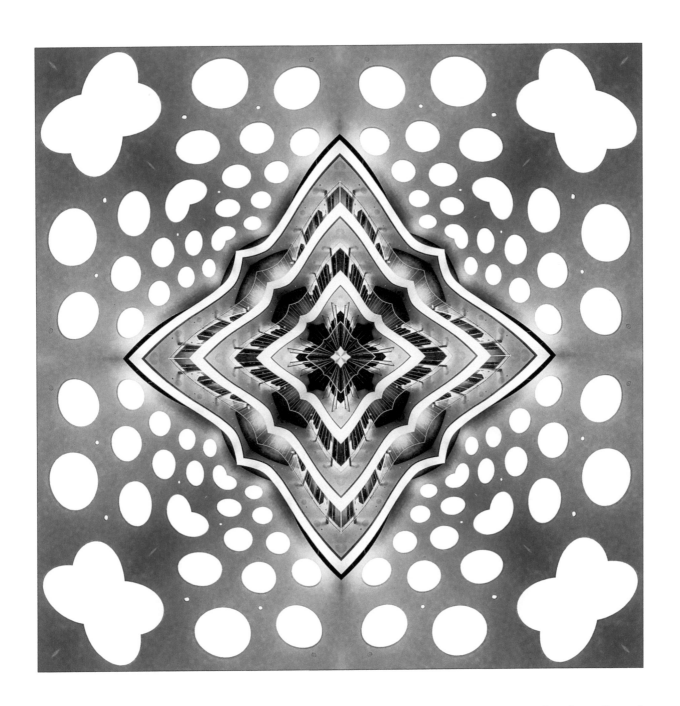

Copenhagen, Denmark

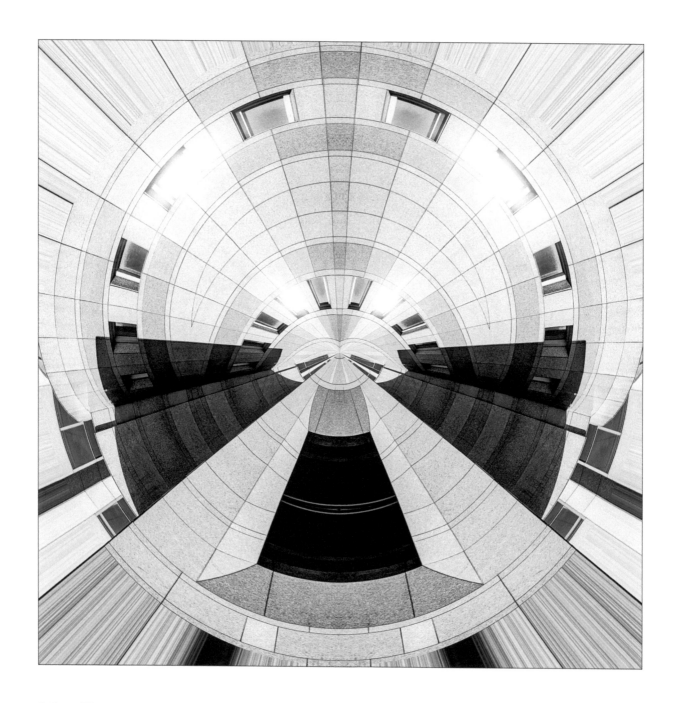

Reflected Projection

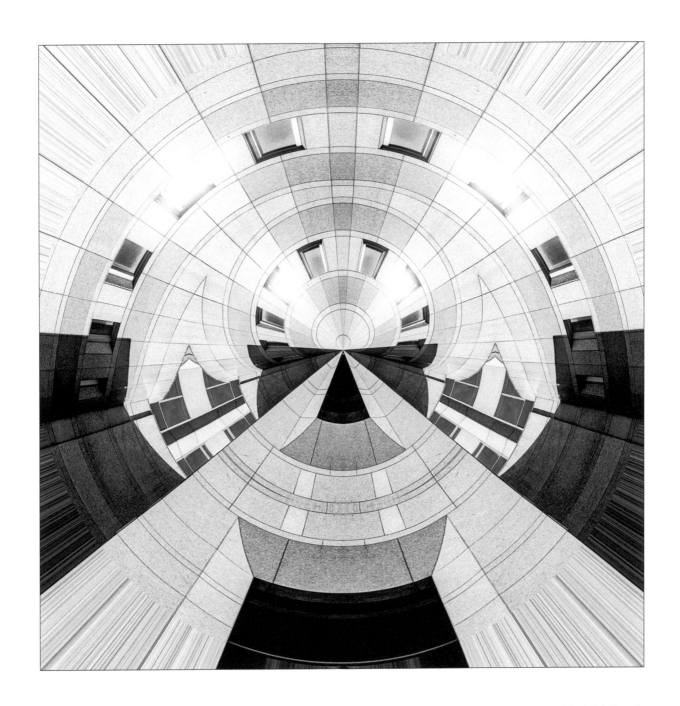

Montréal, Canada

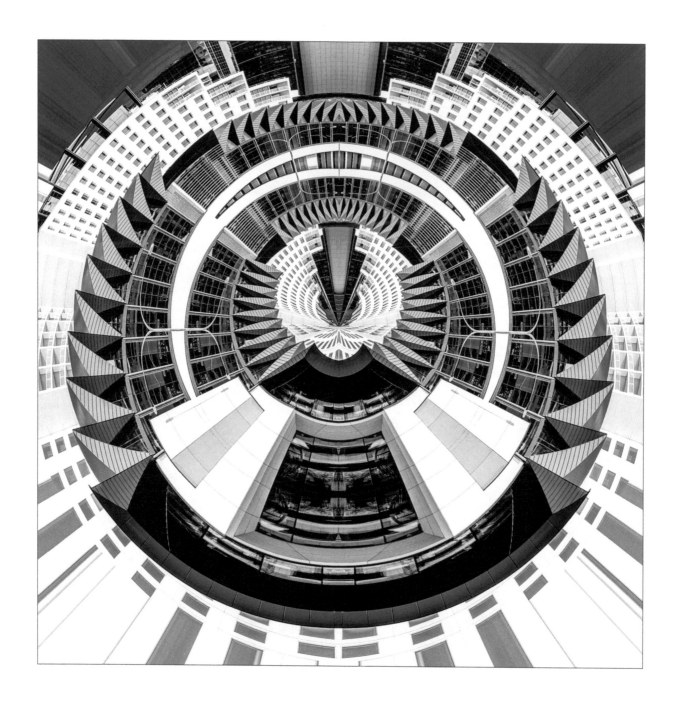

City Machining

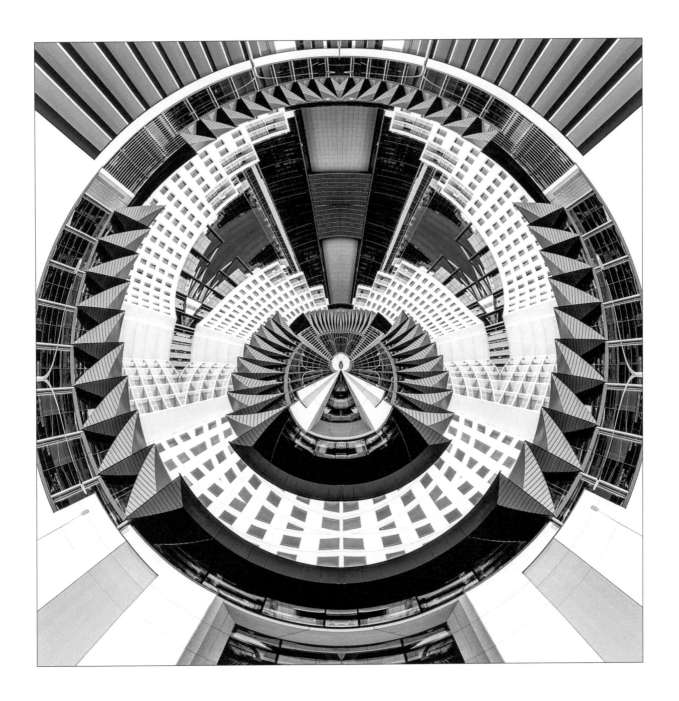

Sydney, Australia

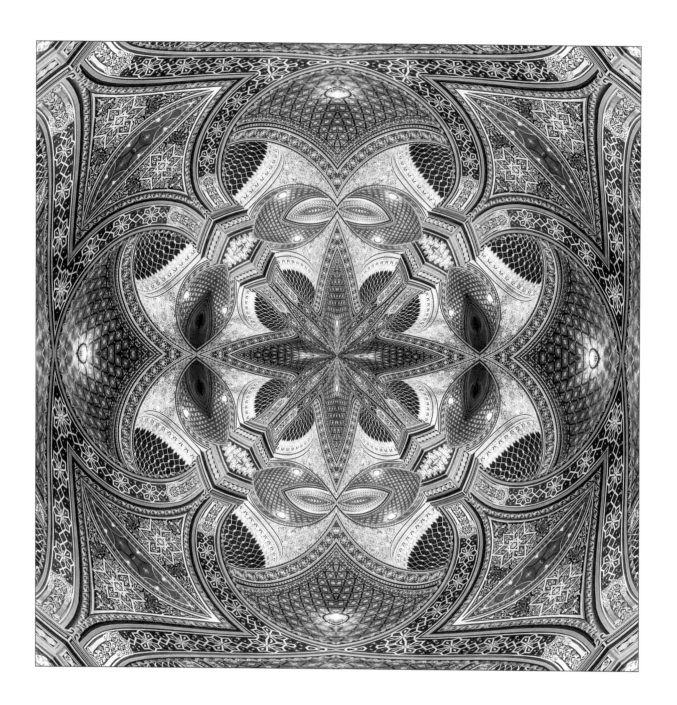

An Infinity of Details

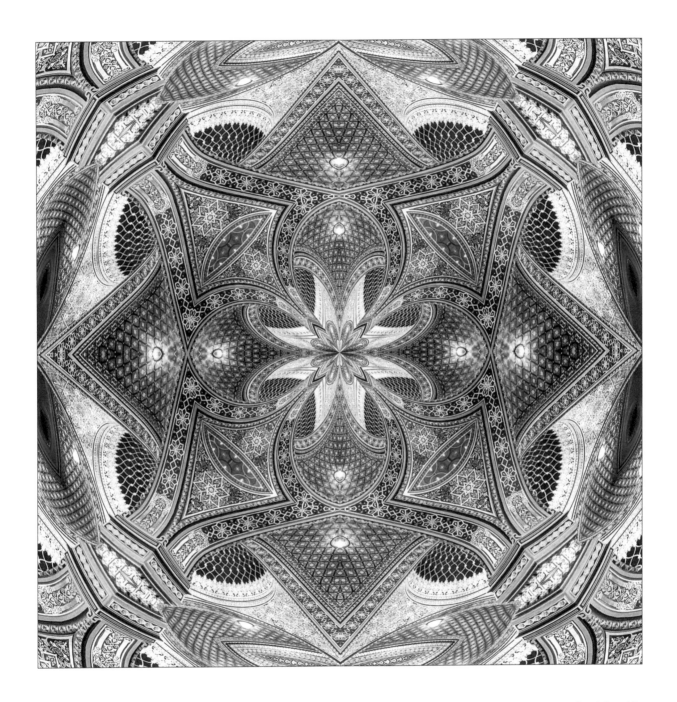

Prague, Czech Republic

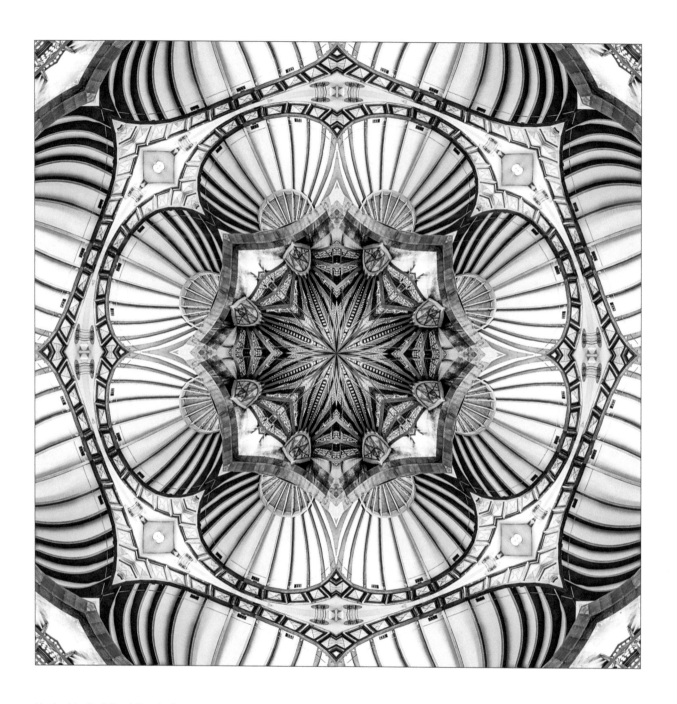

Under Vaulted Steel Seashells

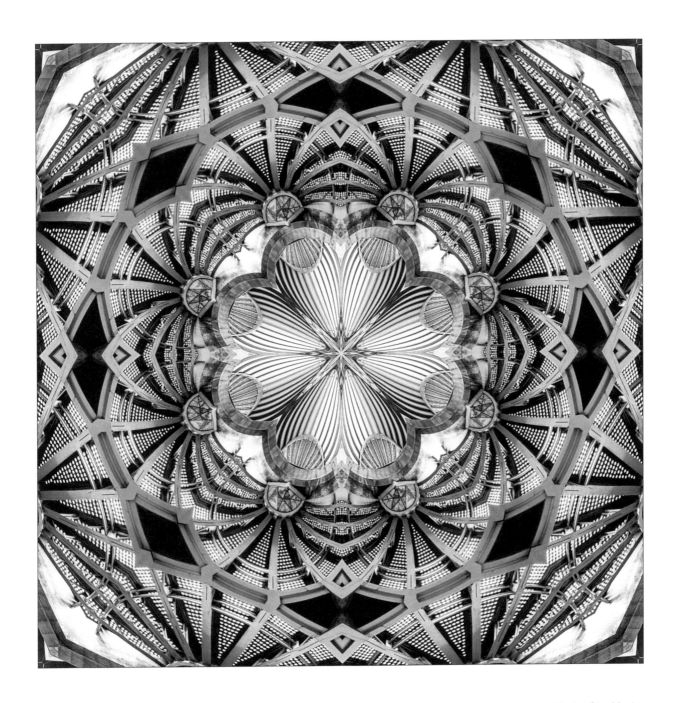

Mexico City, Mexico

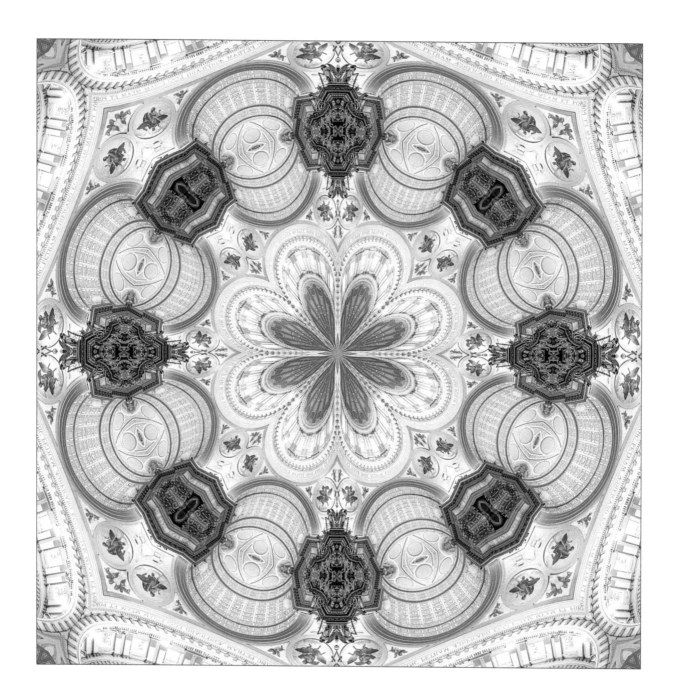

Mary's Anahata

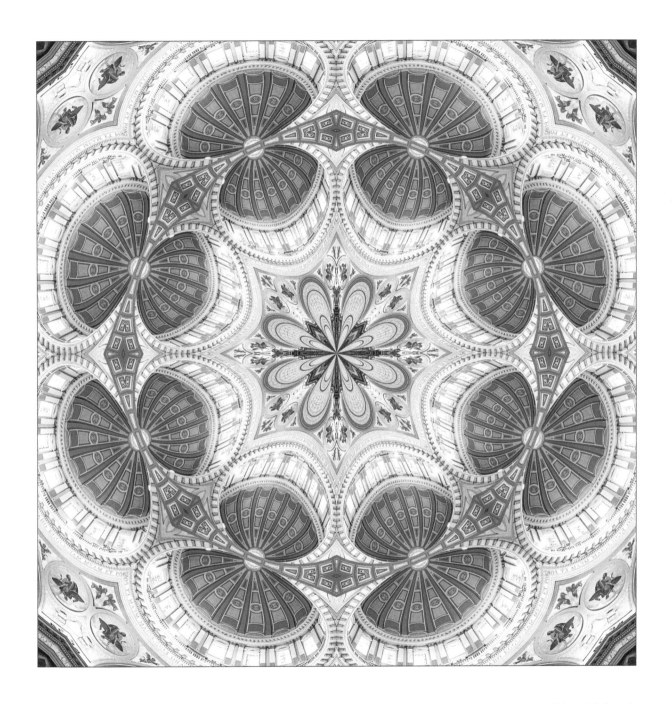

Montréal, Canada

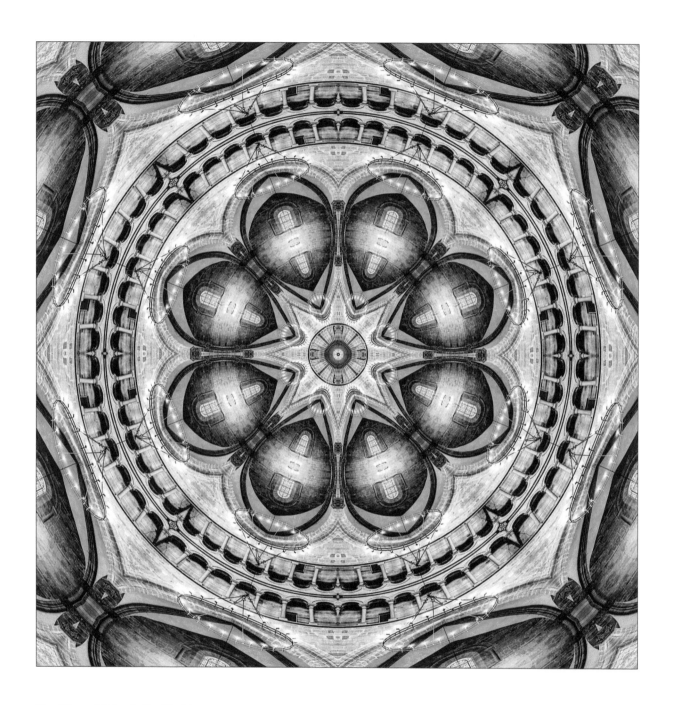

Two Ways of Being In the World

32

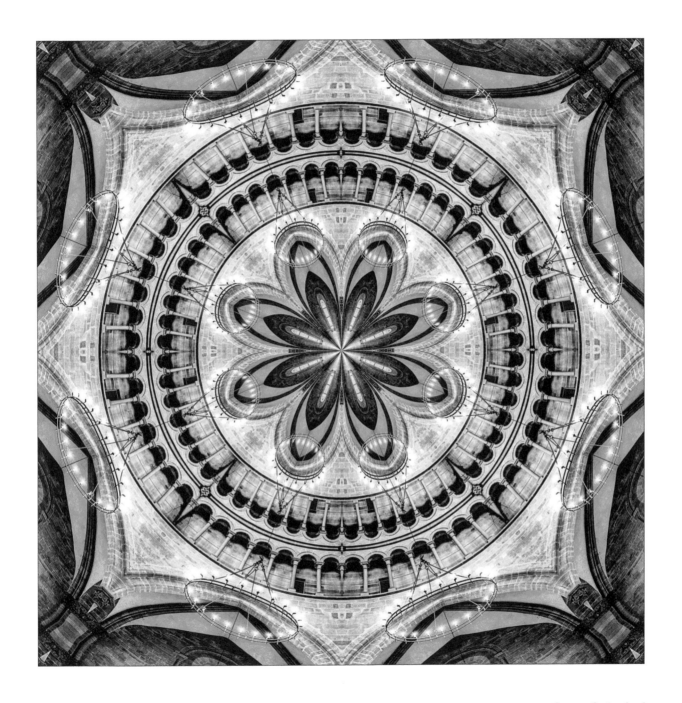

Geneva, Switzerland

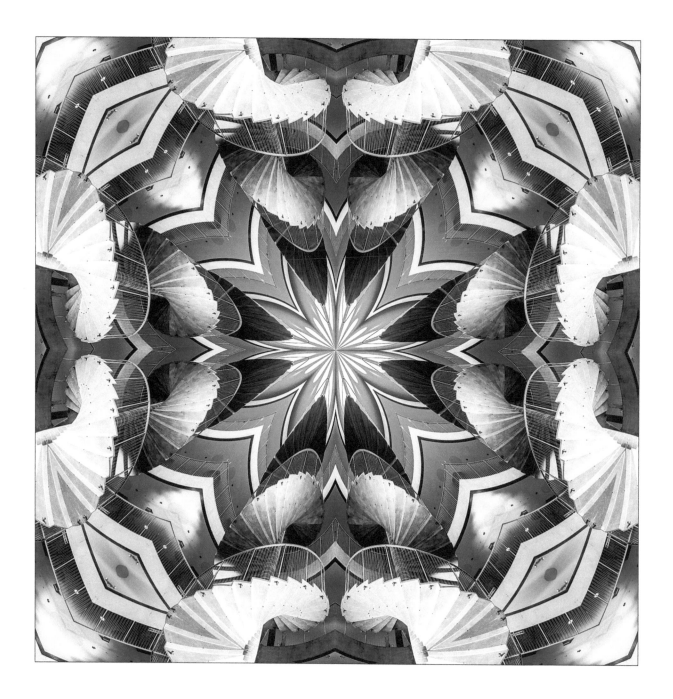

All Paths Have the Same Destination

34

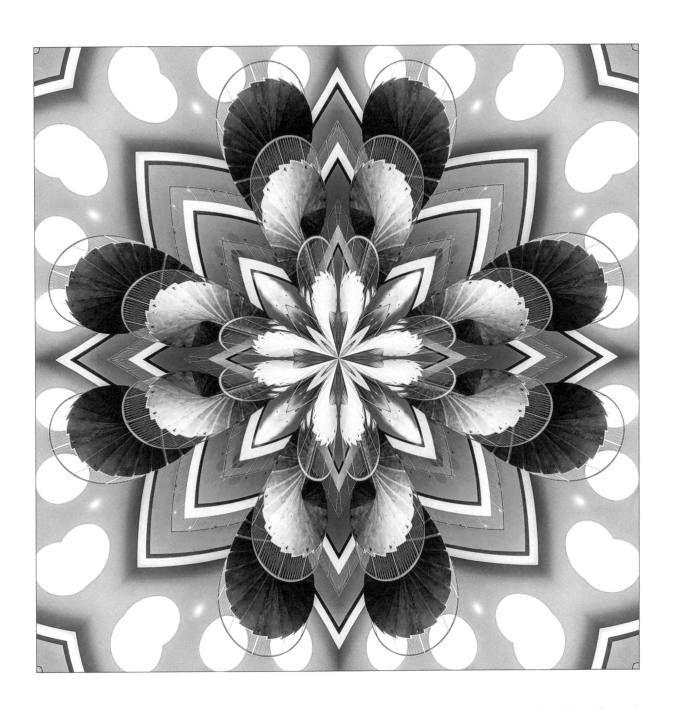

Copenhagen, Denmark

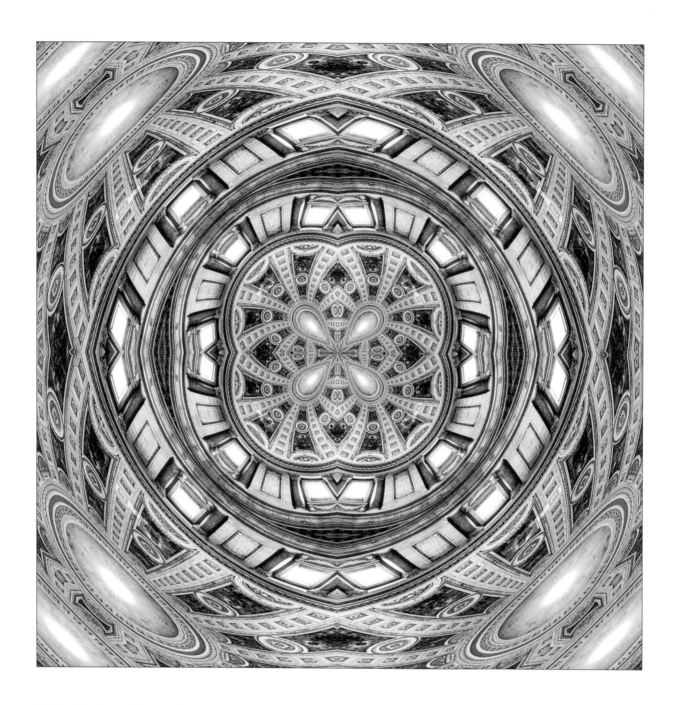

Unity of Center and Surround

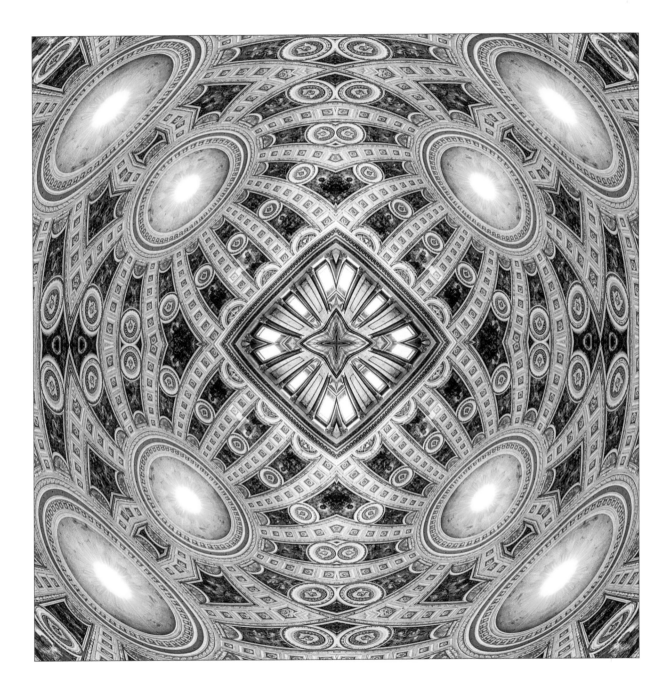

Copenhagen, Denmark

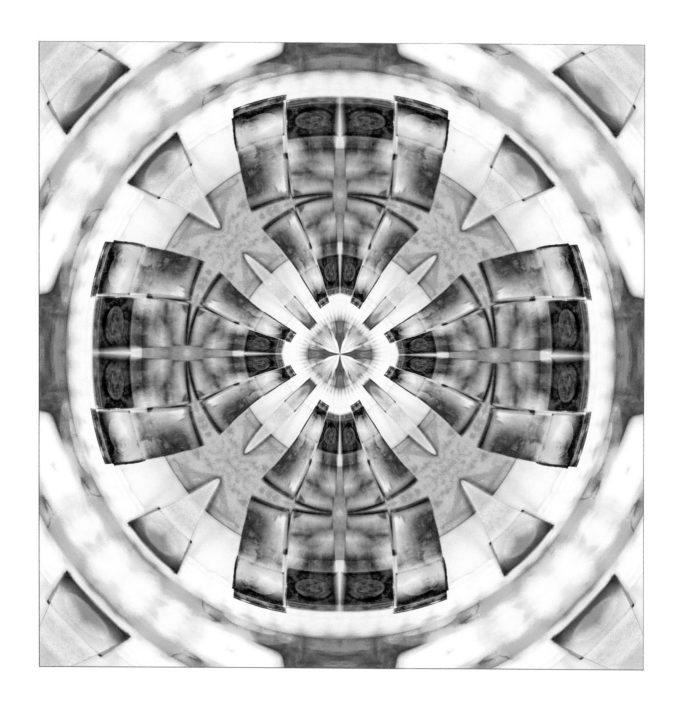

Island of Connections

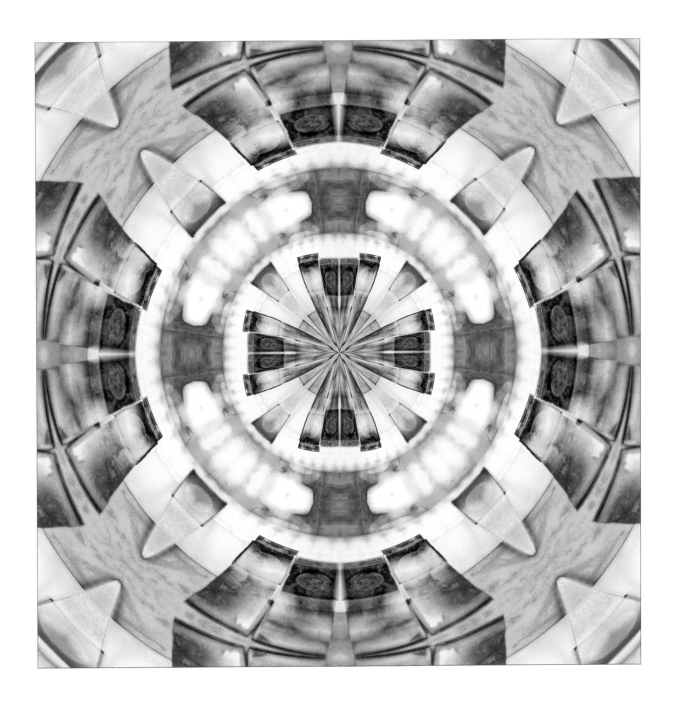

Hanover, NH, United States

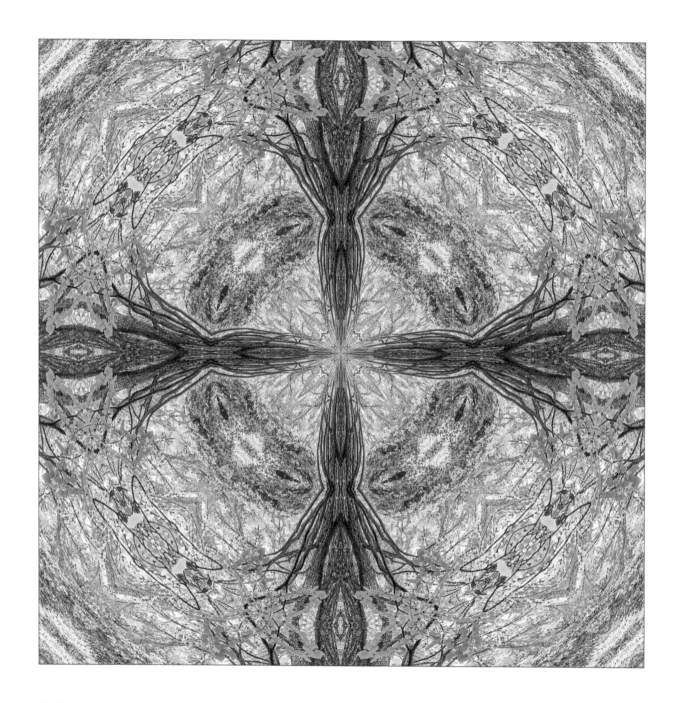

Egoless Ecosystem

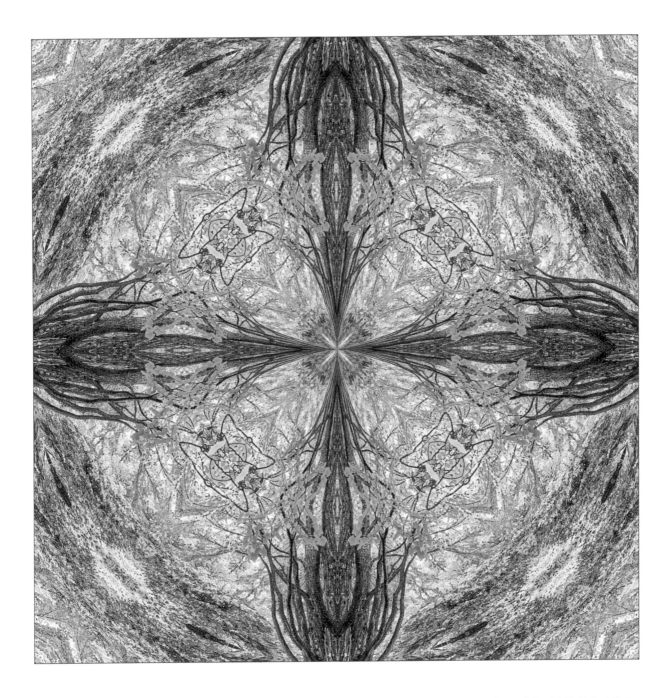

Mount Desert Island, ME, United States

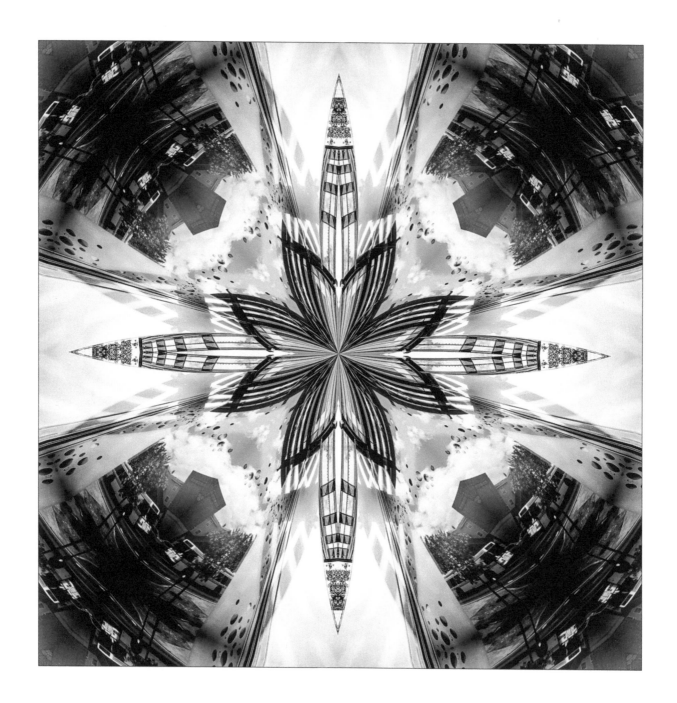

After the Shadows and Structures Merge

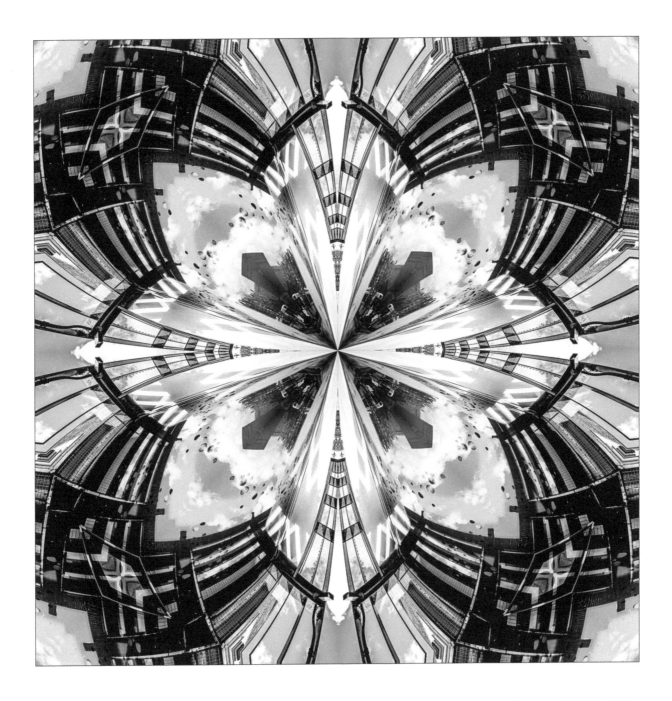

Hanover, NH, United States

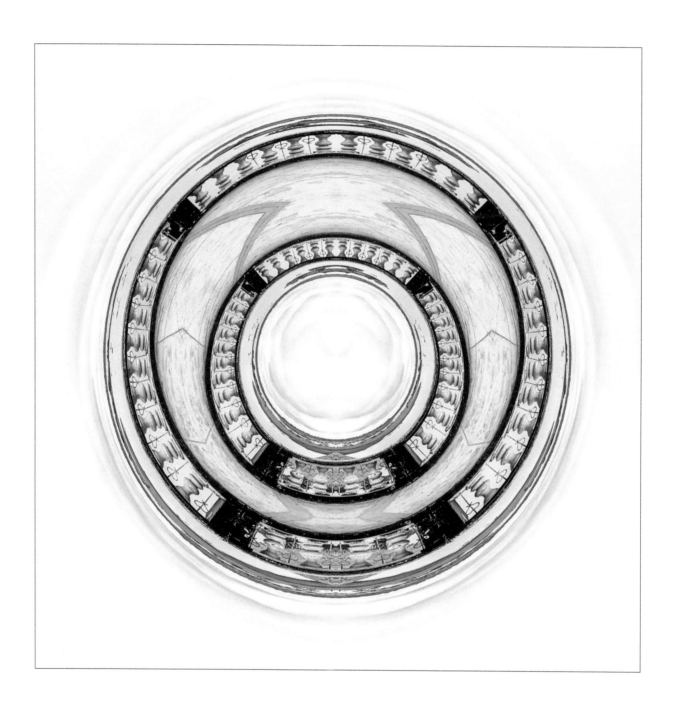

Hearts at the Edge of the Horizon

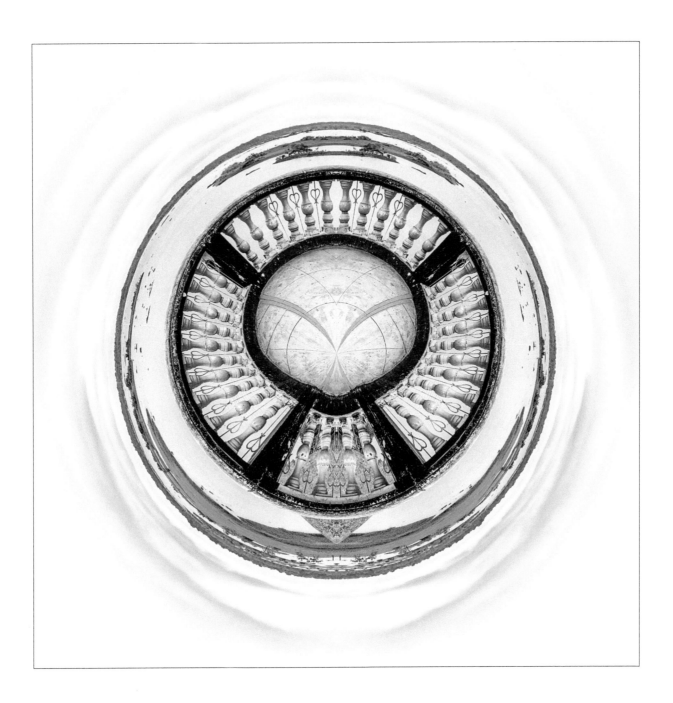

Iquitos, Perú

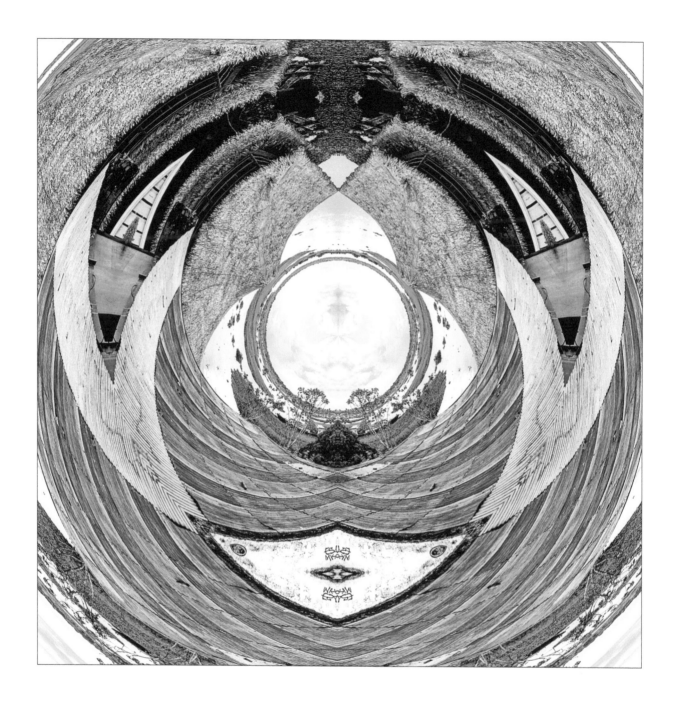

Boundaries of Shelter and Sky

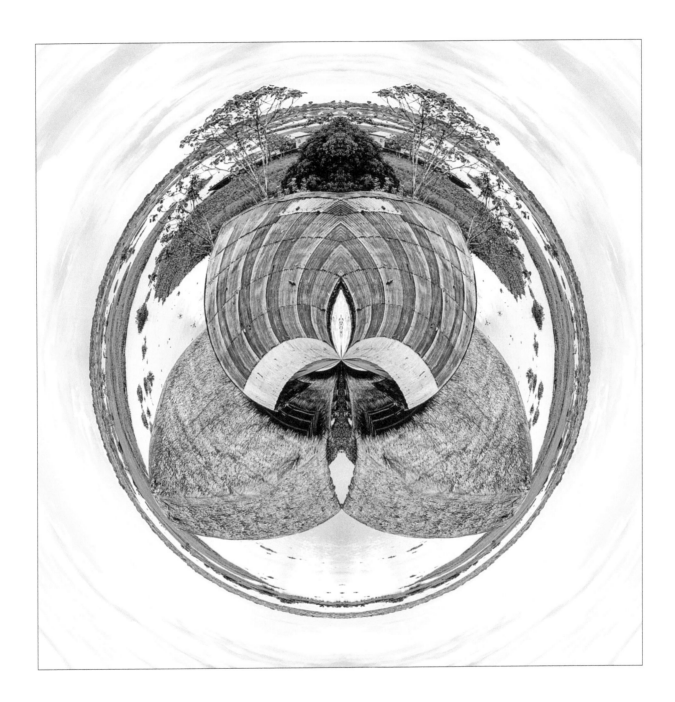

Iquitos, Perú

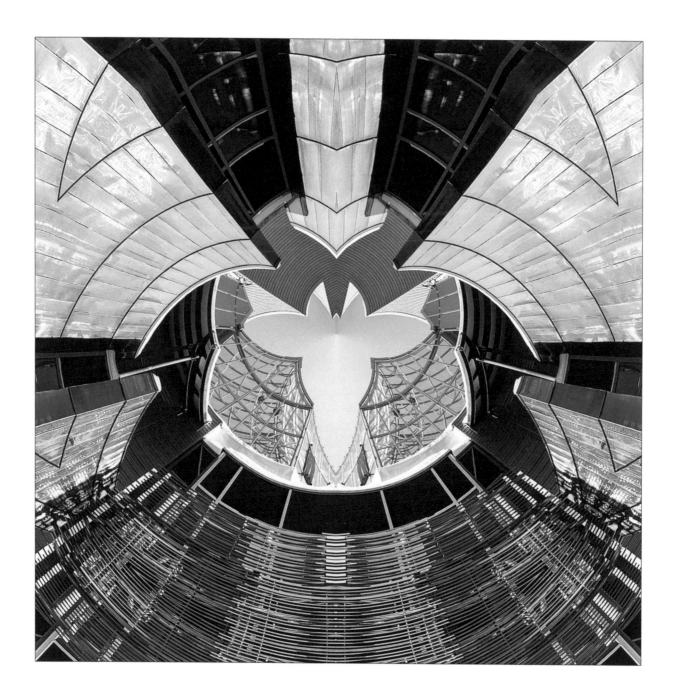

Materialism is Malleable

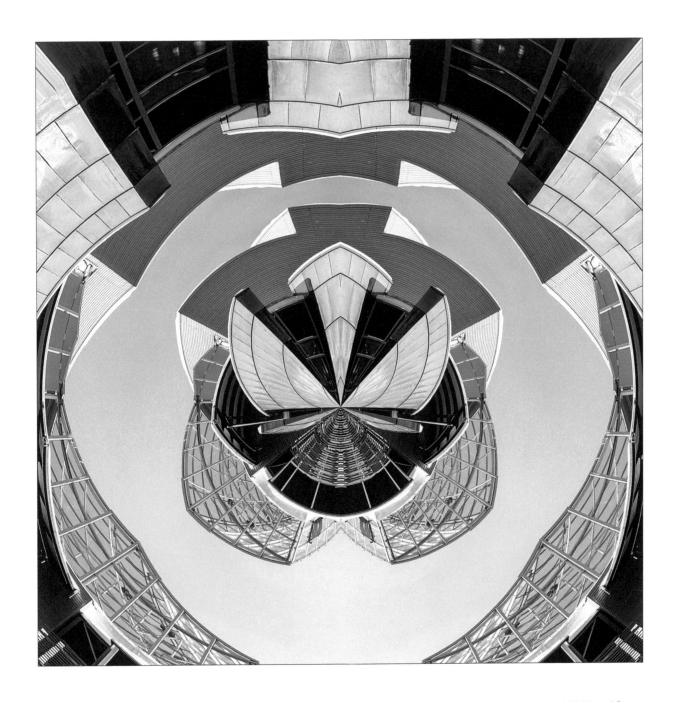

Hanover, NH, United States

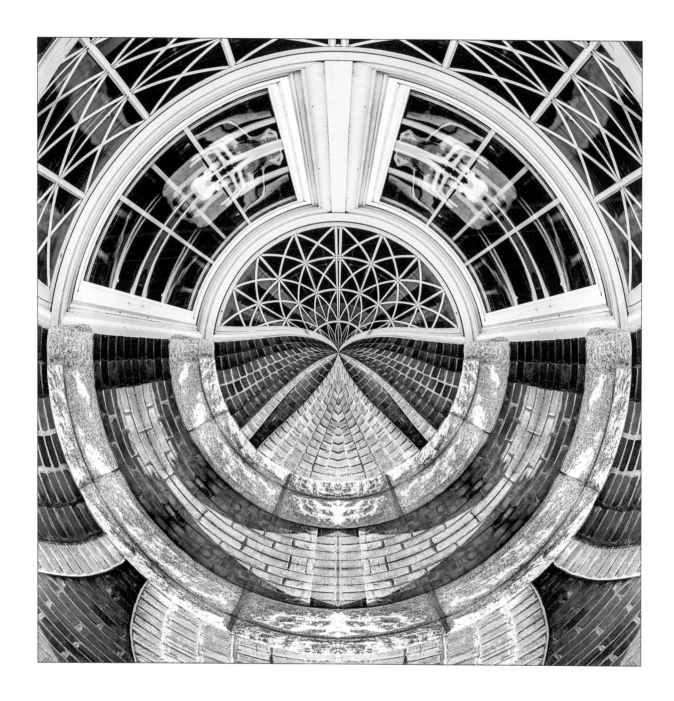

Journey to the Brick-Winged Owl Bat

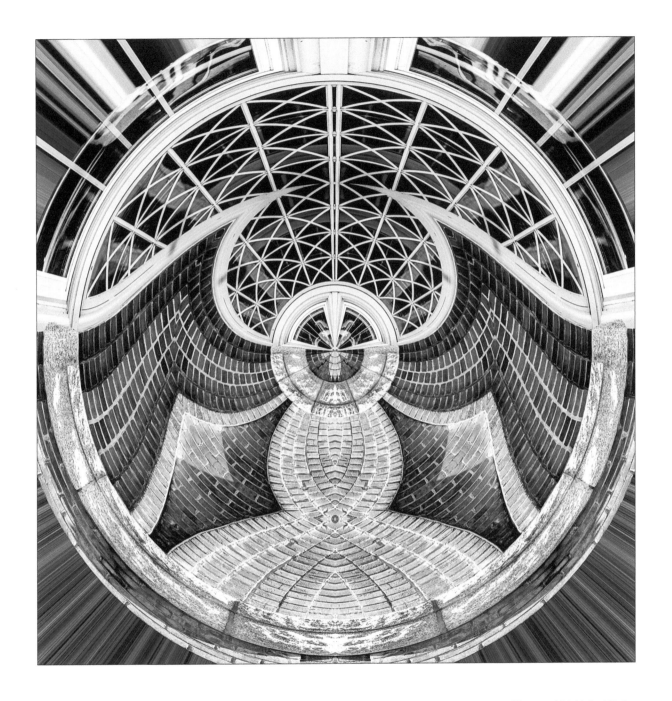

Hanover, NH, United States

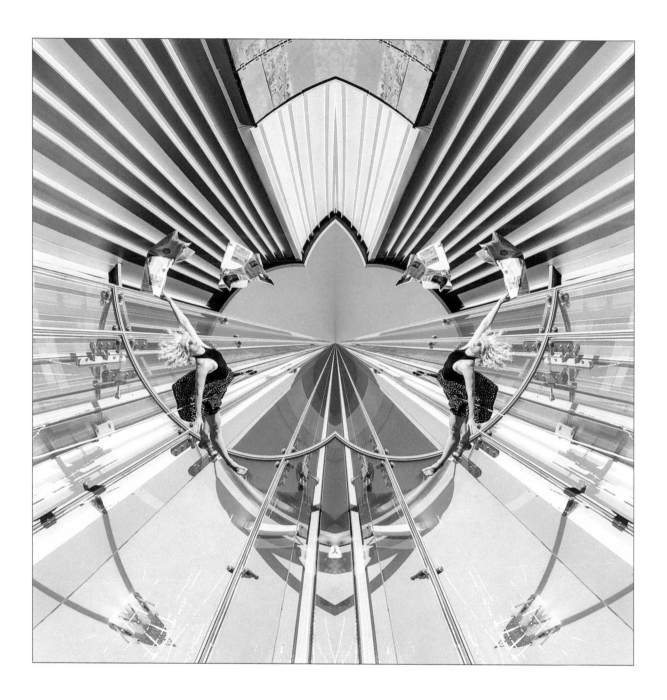

Lisa Bandaloop Has Had Enough With the News

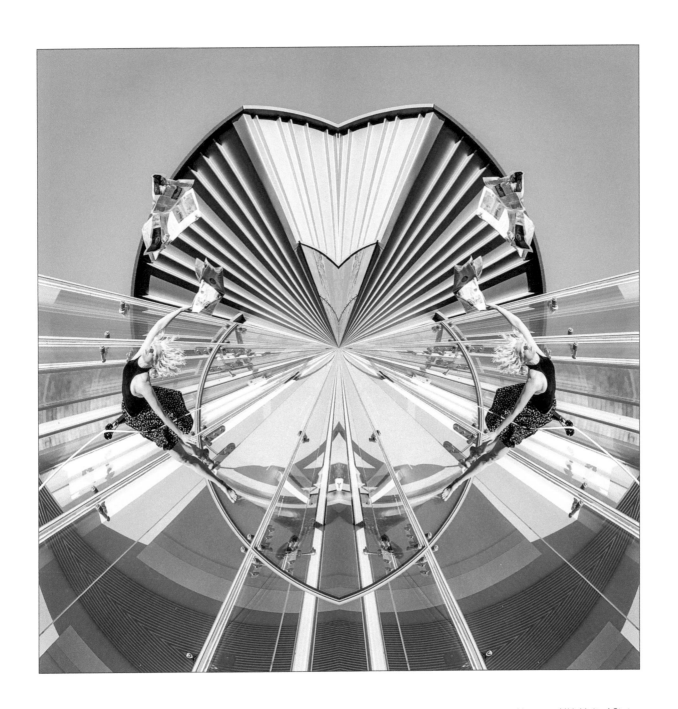

Hanover, NH, United States

Colophon

Similarity was designed and produced by the author, using Affinity Designer, Affinity Photo, and Affinity Publisher.

Equipment
Fujifilm X-H1, RRS BP-CS body plate
Fujifilm X-T2, RRS BP-CS body plate
Fujifilm X100T, 23mm f2, RRS BX100T body plate
Fujinon XF16-55mmF2.8 R LM WR
Laowa 9mm f/2.8 Zero-D
Fujinon XF10-24mmF4, XF55-200mmF3.5-4.8
Canon EOS 5D Mark III, Canon EF 85mm f/1.2L USM
RRS BH-25 ballhead, RRS B2-mAS clamp
Gitzo GT1541T tripod, RRS TFA-01 Ultra Pocket 'Pod
LifePixel 590nm and Hoya 720nm infrared filters

Workflow
Recorded on SanDisk Extreme Pro SDHC & SDXC cards
Processed on an Apple Macbook Pro Retina 13" (2014)
Developed with Adobe Photoshop Lightroom 6.x
Edited using a BenQ SW2700PT monitor
Calibrated with X-Rite i1 Display Pro Colorimeter

Locations
2010–2018 • New England, United States
2015 June • Iquitos, Perú
2015 July • Geneva, Switzerland
2015 December • Mexico City, Mexico
2016 April • Copenhagen, Denmark
2016 April • Prague, Czech Republic
2016 December • Sydney, Australia
2016 December • South Island, New Zealand
2017 March • New York, NY, United States
2017 August • Montréal, Canada
2018 October • Mount Desert Island, ME, United States

About the Author

I have loved making photographs for 50 years. I was first introduced to it by my grandfather, Samuel Hatfield (in Burlington, VT) when I was five or six. Working in a darkroom under dim red light, dipping the paper print in each of three chemical baths, then seeing the image develop before our eyes — my first taste of magic.

My family lived in New England, a place of mountains and lakes, rivers and ocean, woodlands and corn fields. When I was eight we traveled to the American Southwest, and I got to experience a completely different landscape: flat deserts and dry riverbeds, scruff trees and cattle pastures, distant mesas and huge thunderstorms a hundred miles away. That contrast struck me, and stayed with me. It taught me something about change and difference, similarity, the importance of paying attention.

By the early 1970s I was tinkering with computing, having expanded beyond the darkroom with a 300-baud acoustic modem to access a university mainframe 20 miles away. The Amiga and the Macintosh PCs landed in my life in the 1980s, and before long I was doing digital video capture and image processing. I installed version 1.0 of Photoshop, and along the way tinkered with MacPaint, DPaint, and the revolutionary Video Toaster.

Today's toolkit includes Fujifilm, Really Right Stuff, and Godox hardware, with Lightroom, Affinity, and Capture One software. But the real effort transcends these ephemera, driven instead by my mindfulness as a humanist, experimentalist, and whole systems strategist. My work — my worldview — is guided by a set of heuristics that prioritize:

- whole systems over fragmented perspectives;
- thoughtful engagement over snap responsiveness;
- emergent mystery over problems/solutions;
- macro-structures over micro-details;
- improvisation within structures over command and control;
- goals and outcomes over deliverables and inputs;
- leadership over management;
- creative and generative over consumptive and extractive;
- expansion over reduction;
- love over fear.

In my photography, I strive to consider the world through these intersecting systems, exploring how elements relate to each other, merging together and separating themselves in our minds, especially over time. I'm still compelled by those early experiences witnessing difference, contrast, and unity. I am attuning to the timeless quality of changeless presence. *Similarity* is a snapshot of this work.

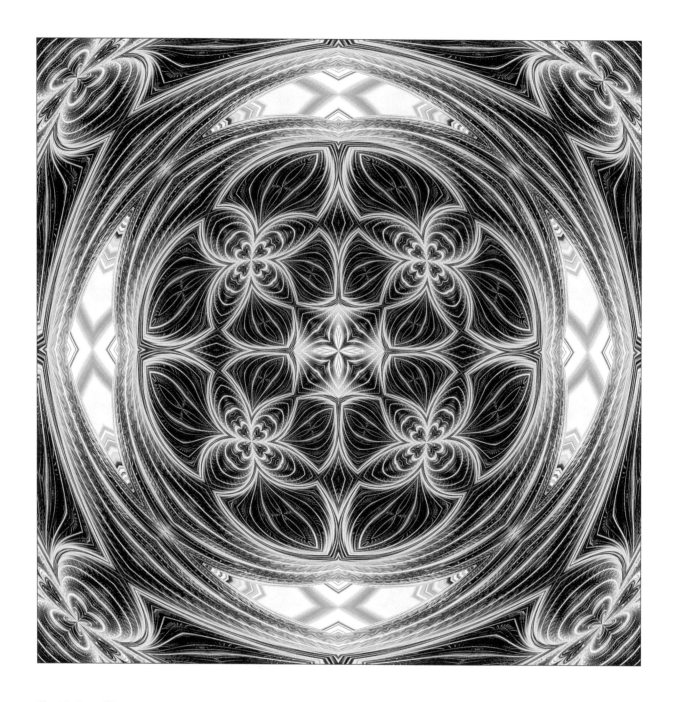

Electric Eyes (b)

Stay Connected

There are several ways for you to engage and stay connected with me and *Similarity*.

Pen Pals

You can receive email with news of my experiments and new work, perhaps an occasional philosophical reverie, a discount coupon for fine art prints, or other free gifts such as phone wallpapers. Emails are low-key and friendly – convivial, even – and not too frequent. When you sign up you'll also get a special email address for you to use to contact me. Visit *www.MichaelYacavone.com/penpals*

Mount & Frame

You may purchase fine art prints on paper (optionally matted and framed), or on canvas, metal, acrylic, or custom materials. The *Similarity* series prints wonderfully at large sizes and high resolutions, and also looks great when sized to fit in a desk frame. If you'd like to have a *Similarity* pair produced for your home or office, visit *www.MichaelYacavone.com/gallery*

Private Commission

You can commission original images made from your own public art, architecture, or landscape project. I'm available internationally for commercial and editorial photography of all kinds, especially for travel, culture, real estate, architectural, and humanist projects. Visit *www.MichaelYacavone.com/commissions*

Presentation

If you'd like me to visit your organization, conference, retreat, or home to give a presentation with the ideas and images of *Similarity* uniquely tailored for your event, topic, or audience, let's talk. Reach out via *www.MichaelYacavone.com/present*

Feedback

I welcome your reflections and constructive perspectives. Send me a postcard with three or four words about how the work lands; you may find yourself pleasantly surprised.

Michael Yacavone
XeniumGroup, LLC
PO Box 828
Hanover, NH 03755
United States

Similarity™
A Photographic Contemplation

More than just a beautiful book of visionary photographs, what you are holding in your hands can serve as a guidebook for self-development, a manual for breaking the bonds of dualism and maya, a medicine for the mind, and a pristine projection mirror for finding your true authentic Self — using your own meditative powers to transform your perspective.

Cultivated from over 55,000 photographs made in nine countries, *Similarity* represents a carefully curated collection of 48 mindful images derived from hundreds of experiments in the magical art of digital image processing.

Previously available only as a set of open edition A3-size fine art prints, *Similarity, A Photographic Contemplation* has now been published in this engaging, interactive book. This gorgeous collection makes a great gift for friends and colleagues.

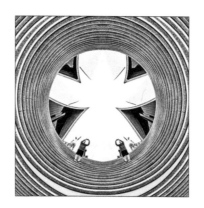 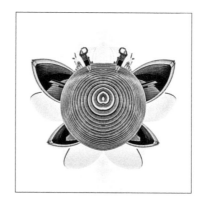

www.SimilarityPhotos.com

ISBN 978-1-7328012-0-2

53999

9 781732 801202

ART / PHOTOGRAPHY / BODY, MIND & SPIRIT

CPSIA information can be obtained
at www.ICGtesting.com
Printed in the USA
BVHW020316081118
532454BV00003B/4/P

* 9 7 8 1 7 3 2 8 0 1 2 0 2 *